# CAUTIONARY TALES FOR CHILDREN

# HILAIRE BELLOC

# CAUTIONARY TALES FOR CHILDREN

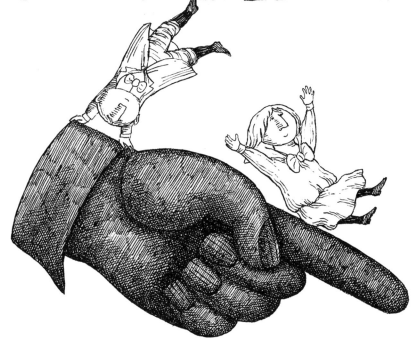

**REDISCOVERED AND ILLUSTRATED BY**

# EDWARD GOREY

Harcourt, Inc.

*New York  San Diego  London*

Requests for permission to make copies of any part
of the work should be mailed to the following address:
Permissions Department, Harcourt, Inc.,
6277 Sea Harbor Drive, Orlando, Florida 32887-6777.

www.HarcourtBooks.com

Text reprinted with permission from Random House UK.

Library of Congress Cataloging-in-Publication Data
Belloc, Hilaire, 1870–1953
Cautionary tales for children/Hilaire Belloc; drawings by
Edward Gorey.—1st ed.
p. cm.
ISBN 0-15-100715-2
1. Conduct of life—Juvenile poetry. 2. Children's poetry, English.
I. Gorey, Edward, 1925–  II.Title.

Printed in china

C E G I K J H F D

# INTRODUCTION

*Upon being asked by a Reader whether
the verses contained in this book were true.*

And is it True?      It is not True.
And if it were it wouldn't do,
For people such as me and you
Who pretty nearly all day long
Are doing something rather wrong.
Because if things were really so,
You would have perished long ago,
And I would not have lived to write
The noble lines that meet your sight,
Nor [Edward G.] survived to draw
The nicest things you ever saw.

—HILAIRE BELLOC

# Jim,

## Who ran away from his Nurse, and was eaten by a Lion.

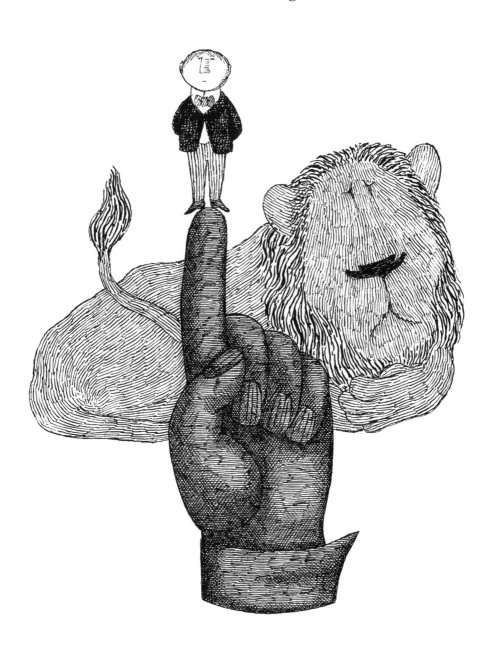

There was a Boy whose name was Jim;
His Friends were very good to him.
They gave him Tea, and Cakes, and Jam,
And slices of delicious Ham,
And Chocolate with pink inside,

And little Tricycles to ride,

And read him Stories through and through,

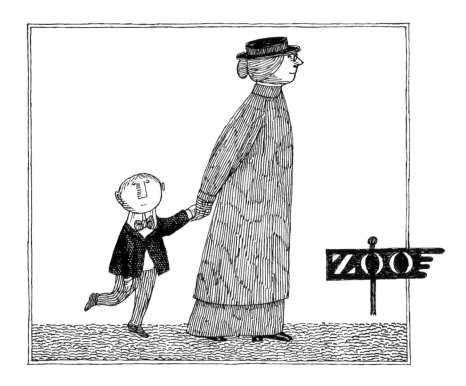

And even took him to the Zoo—
But there it was the dreadful Fate
Befell him, which I now relate.

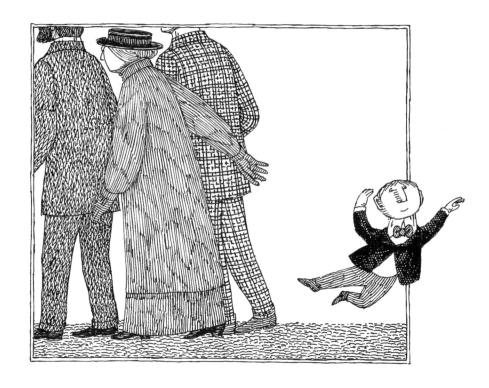

You know—at least you *ought* to know,
For I have often told you so—
That Children never are allowed
To leave their Nurses in a Crowd;
Now this was Jim's especial Foible,
He ran away when he was able,
And on this inauspicious day
He slipped his hand and ran away!

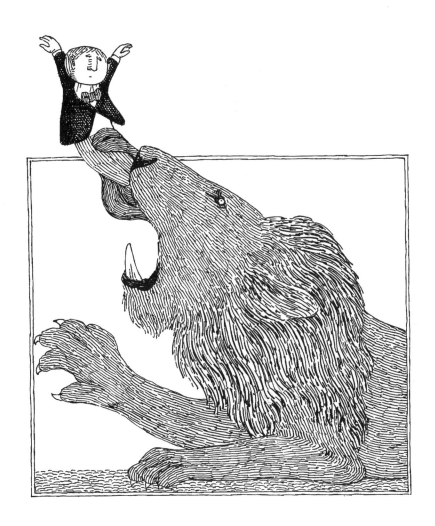

He hadn't gone a yard when—Bang!
With open Jaws, a Lion sprang,
And hungrily began to eat
The Boy: beginning at his feet.

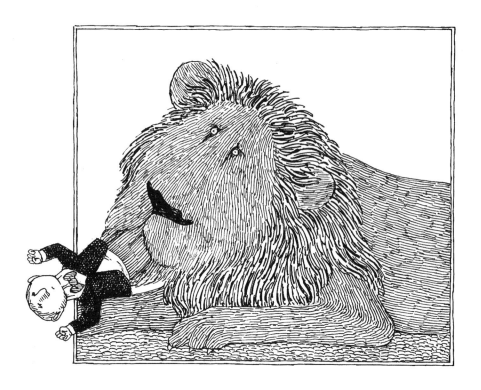

Now, just imagine how it feels
When first your toes and then your heels,
And then by gradual degrees,
Your shins and ankles, calves and knees,
Are slowly eaten, bit by bit.
No wonder Jim detested it!
No wonder that he shouted "Hi!"

The Honest Keeper heard his cry,
Though very fat he almost ran
To help the little gentleman.
"Ponto!" he ordered as he came
(For Ponto was the Lion's name),

"Ponto!" he cried, with angry Frown.
"Let go, Sir! Down, Sir! Put it down!"
The Lion made a sudden Stop,
He let the Dainty Morsel drop,
And slunk reluctant back to his Cage,
Snarling with Disappointed Rage.

But when he bent him over Jim,
The Honest Keeper's Eyes were dim.
The Lion having reached his Head,
The Miserable Boy was dead!

When Nurse informed his Parents, they
Were more Concerned than I can say.
His Mother, as She dried her eyes,
Said, "Well—it gives me no surprise,
He would not do as he was told!"

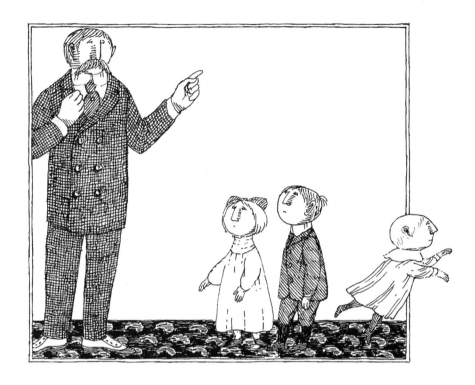

His Father, who was self-controlled,
Bade all the children round attend
To James's miserable end,
And always keep a-hold of Nurse
For fear of finding something worse.

# Henry King,

*Who chewed bits of String,
and was early cut off
in Dreadful Agonies.*

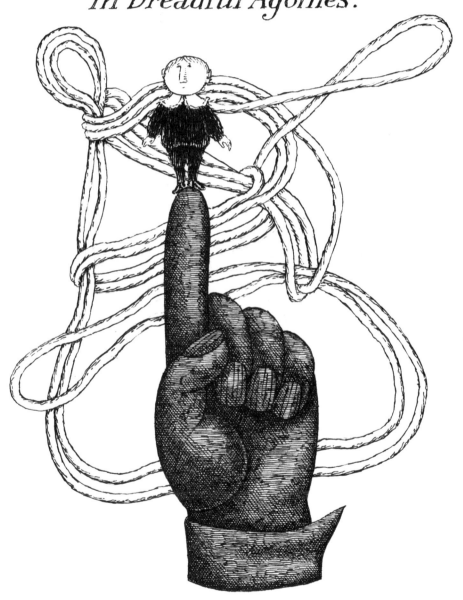

The Chief Defect of Henry King
Was chewing little bits of String.
At last he swallowed some which tied
Itself in ugly Knots inside.

Physicians of the Utmost Fame
Were called at once; but when they came
They answered, as they took their Fees,
"There is no Cure for this Disease.
Henry will very soon be dead."

His Parents stood about his Bed
Lamenting his Untimely Death,

When Henry, with his Latest Breath,
Cried—"Oh, my Friends, be warned by me,
That Breakfast, Dinner, Lunch, and Tea
Are all the Human Frame requires..."
With that, the Wretched Child expires.

# Matilda,

### *Who told lies, and was Burned to Death.*

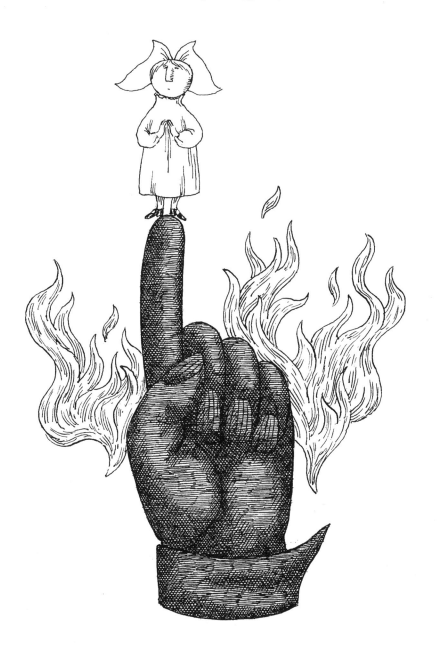

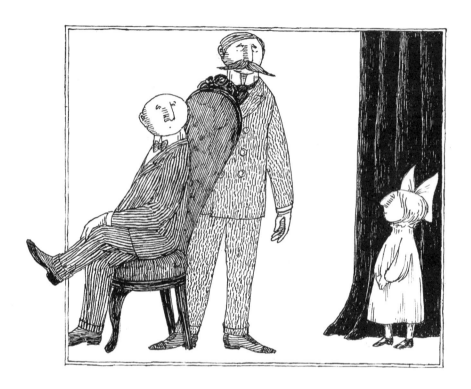

Matilda told such Dreadful Lies,
It made one Gasp and Stretch one's Eyes;

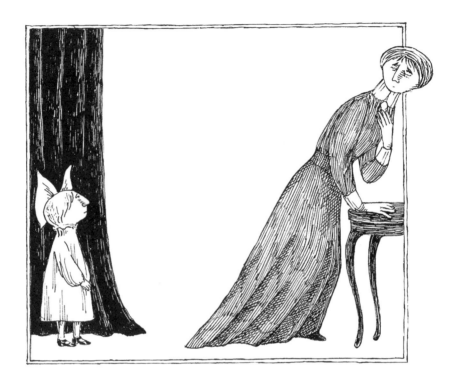

Her Aunt, who, from her Earliest Youth,
Had kept a Strict Regard for Truth,
Attempted to Believe Matilda:
The effort very nearly killed her,
And would have done so, had not She
Discovered this Infirmity.

For once, towards the Close of Day,
Matilda, growing tired of play,

And finding she was left alone,
Went tiptoe to the Telephone
And summoned the Immediate Aid
Of London's Noble Fire-Brigade.

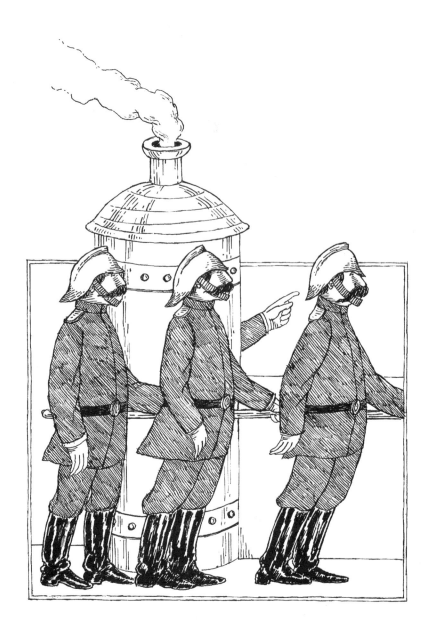

Within an hour the Gallant Band
Was pouring in on every hand,
From Putney, Hackney Downs, and Bow,
With Courage high and Hearts a-glow
They galloped, roaring through the Town,
"Matilda's House is Burning Down!"

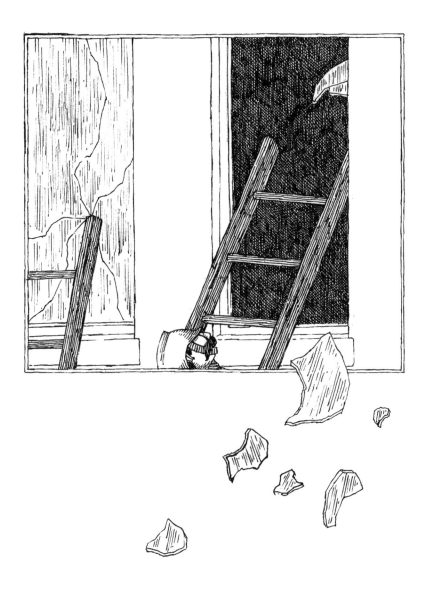

Inspired by British Cheers and Loud
Proceeding from the Frenzied Crowd,
They ran their ladders through a score
Of windows on the Ball Room Floor;

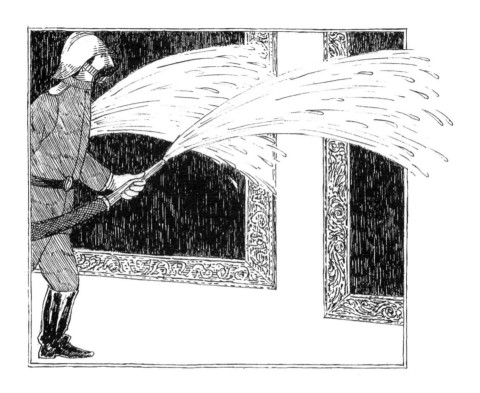

And took Peculiar Pains to Souse
The Pictures up and down the House,

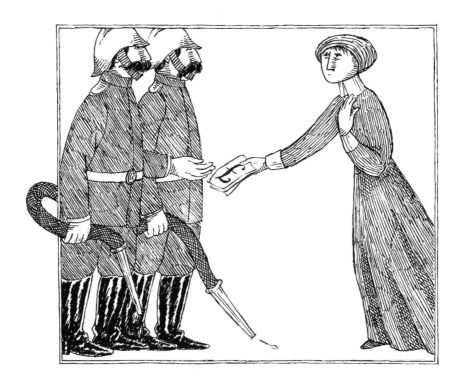

Until Matilda's Aunt succeeded
In showing them they were not needed;
And even then she had to pay
To get the Men to go away!

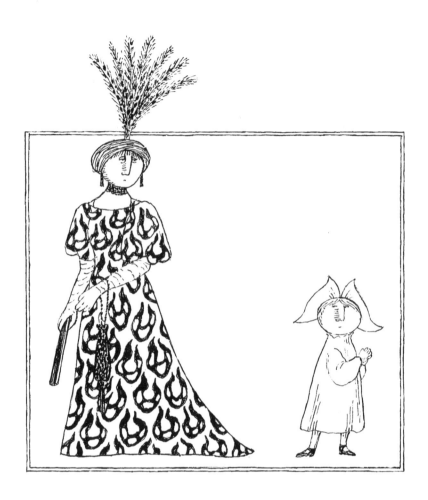

It happened that a few Weeks later
Her Aunt was off to the Theatre
To see that Interesting Play
*The Second Mrs. Tanqueray.*
She had refused to take her Niece
To hear this Entertaining Piece:
A Deprivation Just and Wise
To Punish her for Telling Lies.

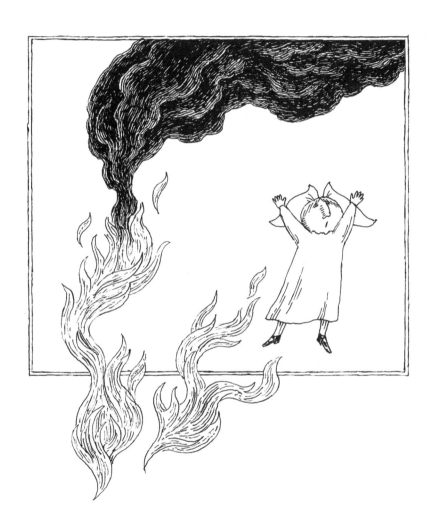

That Night a Fire *did* break out—
You should have heard Matilda Shout!

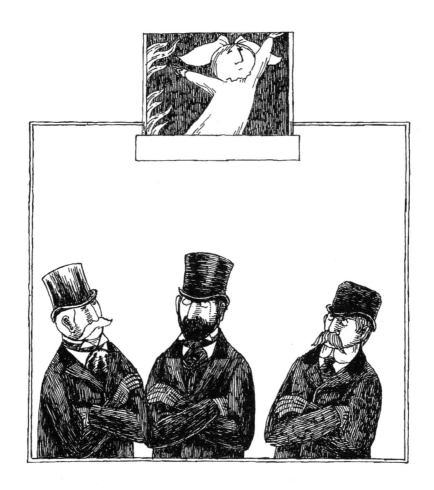

You should have heard her Scream and Bawl,
And throw the window up and call
To People passing in the Street—
(The rapidly increasing Heat
Encouraged her to obtain
Their confidence)—but all in vain!
For every time She shouted "Fire!"
They only answered "Little Liar!"

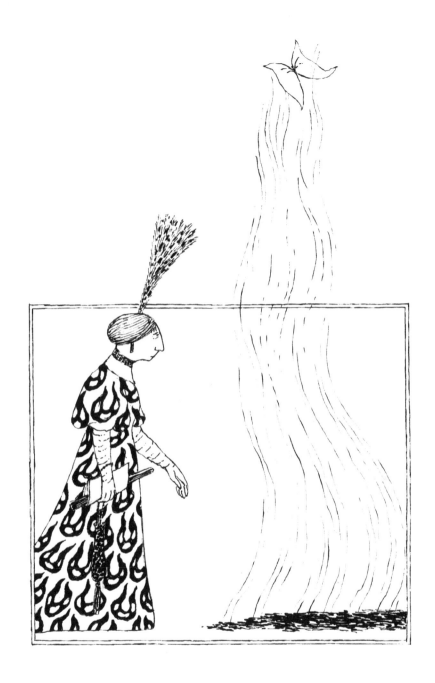

And therefore when her Aunt returned,
Matilda, and the House, were Burned.

# Franklin Hyde,

*Who caroused in the Dirt,
and was corrected by his Uncle.*

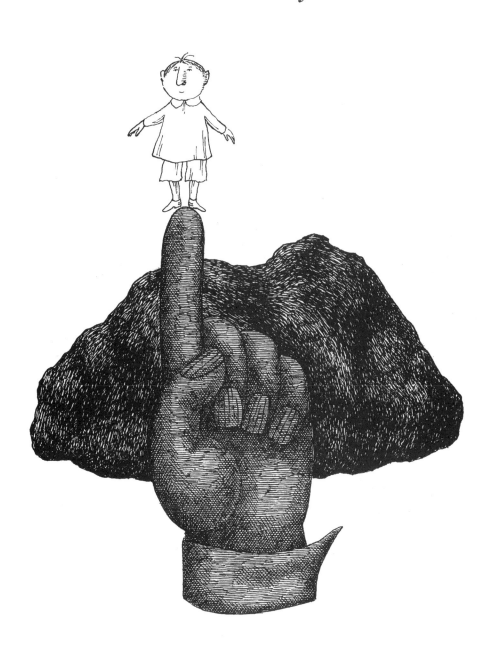

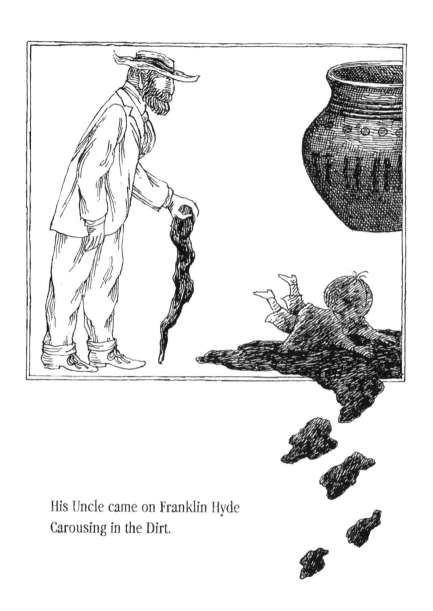

His Uncle came on Franklin Hyde
Carousing in the Dirt.

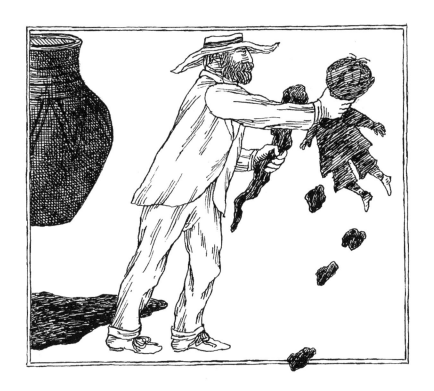

He Shook him hard from Side to Side
And hit him till it Hurt,
Exclaiming, with a Final Thud,
"Take that! Abandoned Boy!
For Playing with Disgusting Mud
As though it were a Toy!"

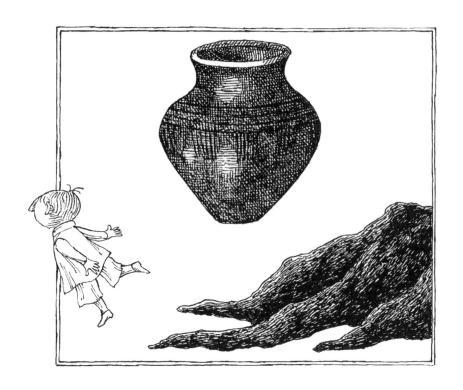

MORAL.
From Franklin Hyde's adventure, learn
To pass your Leisure Time
In Cleanly Merriment, and turn
From Mud and Ooze and Slime
And every form of Nastiness—

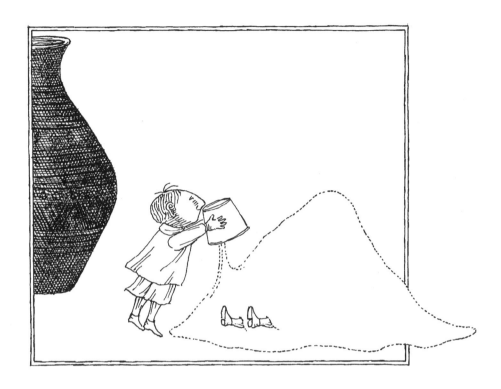

But, on the other Hand,
Children in ordinary Dress
May always play with Sand.

# Godolphin Horne,

## Who was cursed with the Sin of Pride, and Became a Boot-Black.

Godolphin Horne was Nobly Born;
He held the Human Race in Scorn,
And lived with all his Sisters where
His Father lived, in Berkeley Square.

And oh! the Lad was Deathly Proud!
He never shook your Hand or Bowed,
But merely smirked and nodded thus:
How perfectly ridiculous!
Alas! That such Affected Tricks
Should flourish in a Child of Six!
(For such was Young Godolphin's age.)

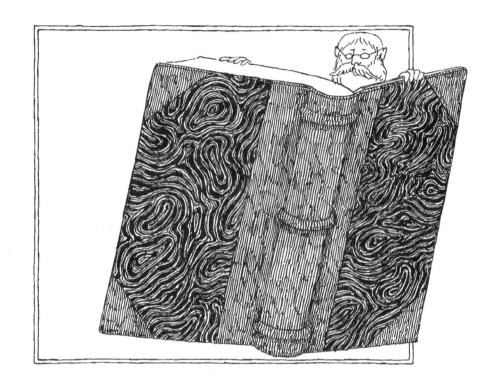

Just then, the Court required a Page,
Whereat the Lord High Chamberlain
(The Kindest and the Best of Men),
He went good-naturedly and took
A Perfectly Enormous Book
Called *People Qualified to Be*
*Attendant on His Majesty,*
And murmured, as he scanned the list
(To see that no one should be missed),

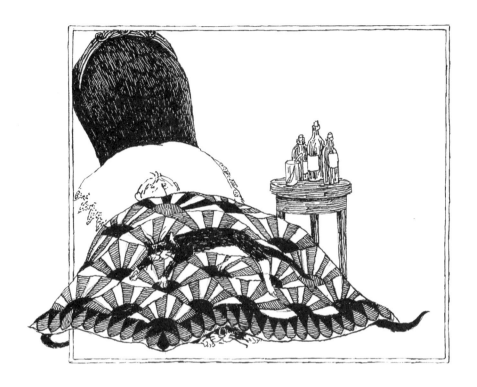

There's William Coutts has got the Flu,

And Billy Higgs would never do,

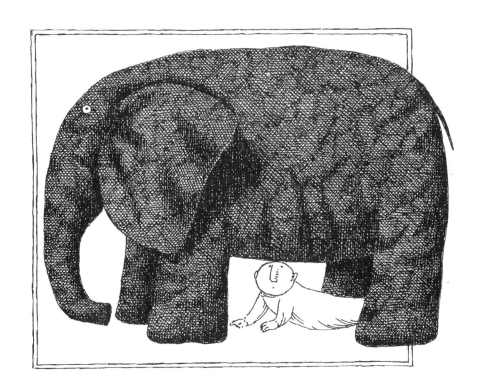

And Guy de Vere is far too young,

And ... wasn't D'Alton's Father hung?

And as for Alexander Byng!—...

I think I know the kind of thing,
A Churchman, cleanly, nobly born,
Come let us say Godolphin Horne?"
But hardly had he said a word
When Murmurs of Dissent were heard.
The King of Iceland's Eldest Son
Said, "Thank you! I am taking none!"

The Aged Duchess of Athlone
Remarked, in her sub-acid tone,
"I doubt if He is what we need!"
With which the Bishops all agreed;

And even Lady Mary Flood
(*So* Kind, and oh! so *really* good)
Said, "No! He wouldn't do at all,
He'd make us feel a lot too small."

The Chamberlain said, "...Well, well, well!
No doubt you're right....One cannot tell!"
He took his Gold and Diamond Pen
And Scratched Godolphin out again.
So now Godolphin is the Boy
Who blacks the Boots at the Savoy.

# Algernon,

Who played with a Loaded Gun,
and, on missing his Sister, was
reprimanded by his Father.

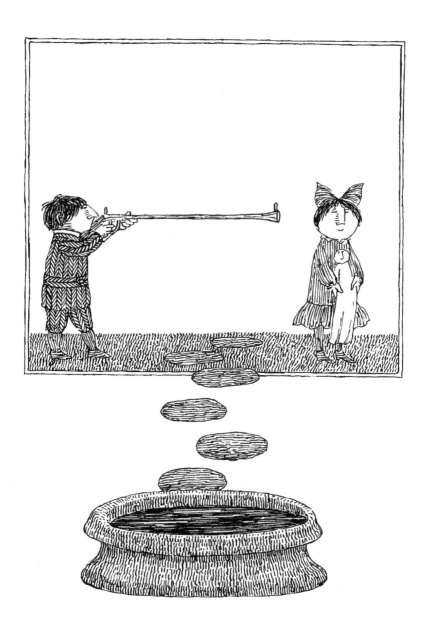

Young Algernon, the Doctor's Son,
Was playing with a Loaded Gun.
He pointed it towards his sister,
Aimed very carefully, but Missed her!

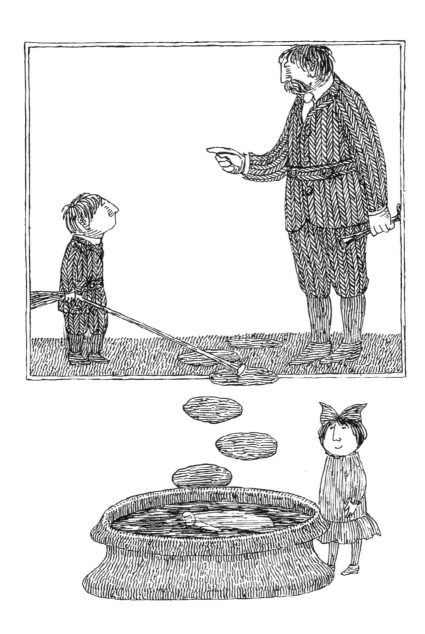

His Father, who was standing near,
The Loud Explosion chanced to Hear,
And reprimanded Algernon
For playing with a Loaded Gun.

# Hildebrand,

*Who was frightened by a Passing Motor, and was brought to Reason.*

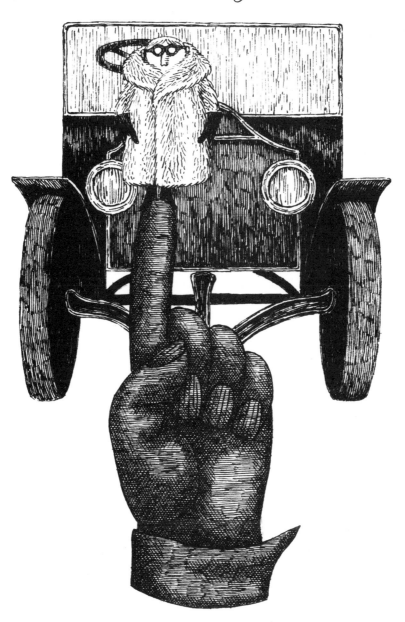

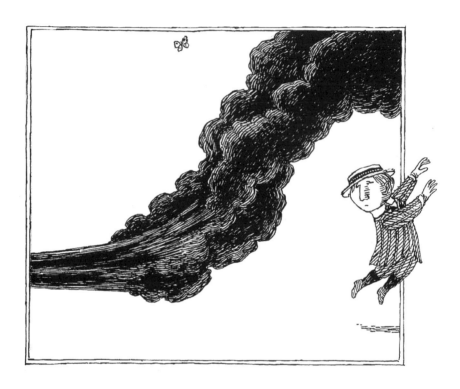

"Oh, Murder! What was that, Papa!"

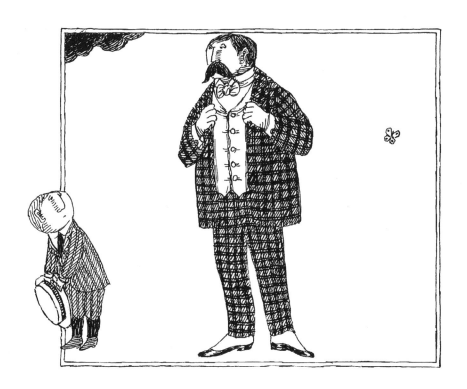

"My child, It was a Motor-Car,
A Most Ingenious Toy!
Designed to Captivate and Charm
Much, rather than to rouse Alarm
In any English Boy.

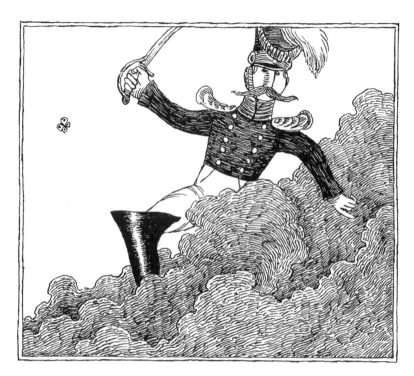

What would your Great Grandfather who
Was Aide-de-Camp to General Brue,
And lost a leg at Waterloo,

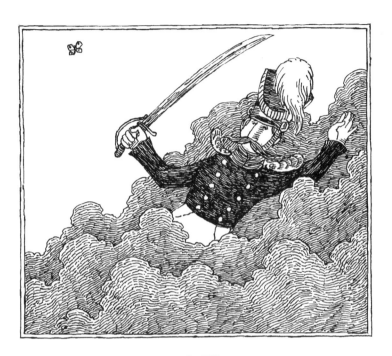

And Quatre-Bras and Ligny too!

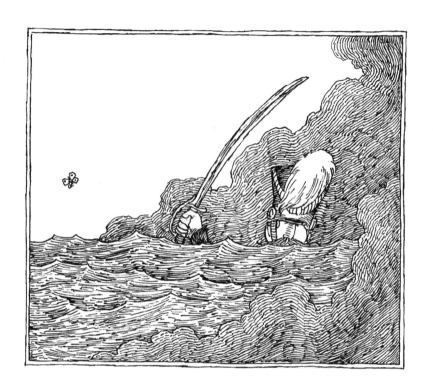

And died at Trafalgar!

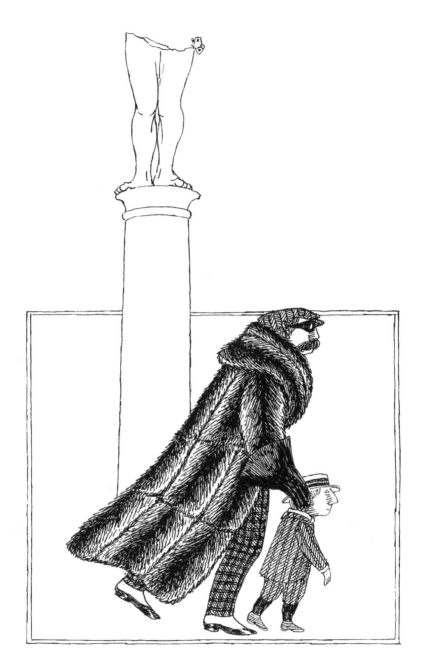

What would he have remarked to hear
His Young Descendant shriek with fear,
Because he happened to be near
    A Harmless Motor-Car!
But do not fret about it! Come!
We'll off to Town and purchase some!"